Vincent Vincent Vin
ent Vincent Vincent
Vincent Vincent Vin
ent Vincent Vincent
Vincent Vincent Vin
ent Vincent Vincent
Vincent Vincent Vin
nt Vincent Vincent
Vincent Vincent Vin
nt Vincent Vincent
Vincent Vincent Vin
nt Vincent Vincent

A SHORT BIOGRAPHY OF VINCENT VAN GOGH

A SHORT BIOGRAPHY OF
Vincent van Gogh

Susan DeLand

BENNA BOOKS
A Boutique Press for Artists & Writers

Carlisle, Massachusetts

A Short Biography of Vincent van Gogh

Series Editor: Susan DeLand
Written by: Susan DeLand

For Bookies-by-the-Sea

Copyright © 2017 Applewood Books, Inc.

978-1-944038-11-3

Front cover: Vincent van Gogh (Dutch, 1853–1890)
Self-Portrait, 1889, oil on canvas, 57.79 x 44.5 cm (22 ¾ x 17 ½ in.)
Collection of Mr. and Mrs. John Hay Whitney
The National Gallery of Art
1998.74.5 Direct Digital Capture Open Access
Back cover: Vincent van Gogh (Dutch, 1853–1890)
Irises, 1889, oil on canvas, 74.3 x 94.3 cm (29 ¼ x 37 ⅛ in.)
The J. Paul Getty Museum, Los Angeles
Digital image courtesy of the Getty's Open Content Program

Published by Benna Books
an imprint of Applewood Books
Carlisle, Massachusetts 01741

To request a free copy of our current catalog
featuring our best-selling books, write to:
Applewood Books
P.O. Box 27
Carlisle, MA 01741
Or visit us on the web at: www.awb.com

10 9 8 7 6 5 4 3 2 1
MANUFACTURED IN THE UNITED STATES OF AMERICA

FLOWERS, TREES, AND THE SKIES above are pulsating, whirling colors captured in reflective oils on canvas. Vincent van Gogh unleashed his life in paintings and in writing. Virtually everything we know about van Gogh comes from his extensive documentation of his everyday life: painting himself, his rooms, villagers, while exchanging close to a thousand letters with his brother, Theo, and others. Theo kept the correspondence, which was published by Theo's wife, Johanna, in 1917. Vincent painted no allegories. He was a journalist of his own life in his art

and his writing. His letters tell us what he was thinking, seeing, reading, and feeling day by day, week by week.

Van Gogh was not an outlier in his family. He came from a long line of diarists, artists, and a number of ancestors who suffered from mental illness. Vincent embodied his heritage, and in him these traits were magnified to hyperbolic levels that exploded on canvas.

Van Gogh's mother, Anna Cornelia Carbentus, was one of nine children born to Willem, the "Royal Bookbinder," in The Hague, Netherlands. Anna was described as manic and moody. She and her sister Cornelia learned to draw and paint, encouraged by their uncle Hermanus, a painter.

The sisters took lessons from Hendrik van de Sande Bakhuyzen, who, with his artist sons and students, would later found the Dutch art movement, The Hague School.

Anna married hastily and late, approaching thirty and ineligibility by the standards of the 1800s. Cornelia, her sister, was engaged to a wealthy print dealer in The Hague named Vincent van Gogh, who had a gallery near the Carbentus shop. Van Gogh's brother, Theodorus (called

Dorus), was a Dutch Reformed minister, handsome, older, and unmarried. He and Anna married soon after meeting and left The Hague to live at the parsonage in the small village of Groot Zundert.

Anna gave birth to a stillborn son on March 30, 1852. It was not the custom to name and memorialize a stillborn child at that time, but the van Goghs chose to name him Vincent and buried him in the churchyard cemetery. On the large headstone was carved a biblical inscription and the name Vincent van Gogh.

Anna became pregnant again and gave birth to a healthy son on March 30, 1853, exactly one year after Vincent's birth. Underscoring the coincidence of birth date, Theodorus and Anna named this baby Vincent Willem van Gogh. Vincent was not an easy child and later wrote of feeling rejected by his mother, who, with her conservative philosophy, found her oldest child's ideas and actions strange as he grew up. Anna was controlling and Dorus, his father, was stern.

Vincent had five siblings: Anna Cornelia, Elisabeth, Willemina, Theodorus, and Cornelius Vincent.

Vincent grew to become a lifelong voracious reader, with Dickens a favorite.

Vincent spent his life fruitlessly seeking their approval.

All was not dark in Vincent's childhood, however. Much of the family time was spent in the parsonage garden, reading aloud to each other: Schiller, Goethe, Shakespeare. Harriet Beecher Stowe's *Uncle Tom's Cabin* arrived in Zundert about the time Vincent was born and was embraced by his parents.

The girls embroidered and made macramé gifts. The boys learned woodworking and pottery. Anna taught all the children to sketch and paint. Vincent took to sketching and did so obsessively. He sometimes traced over his mother's drawings to learn. Dorus, serious and devout, created an isolated life for their children at the parsonage. The children had only each other as playmates. They were taught to show no extremes in emotion, moderating both happiness and misery.

Vincent taught Theo to shoot marbles and build forts. He took him sledding and played games.

Theo was close to his older brother. Their bond was unfailing for their entire lives, though under near-constant strain.

The brothers' personalities were completely opposite. In grade school, one was labeled "strange" and the other "normal." Vincent was intelligent and a quick learner, yet even at seven years of age he rebelled against the strict schoolmaster and was beaten and disciplined. He skipped school repeatedly, and by the second grade his parents began to home-school him.

Vincent was growing into a reclusive and rebellious child, roaming away from the parsonage, exploring the countryside. He studied birds, insects, and plants, sitting on the bank of the Grote Beek. He walked for miles in storms and at night. He would come home with clothes and boots dirty and tattered. This behavior was not acceptable in the van Gogh family.

The Provily School in Zevenbergen was elite. It was not a good fit for an emotional and unruly child. Next was the Rijksschool Willem II in Tilburg, where he was miserable and begged to come home. Vincent seems to have drifted through these years in a daze of melancholy, feeling in-

Frustrated with home-schooling, he was sent off to boarding school at the age of eleven.

creasingly isolated and abandoned by his family. In 1868, just before the end of the term, fifteen-year-old Vincent ran away from the Rijksschool.

Vincent was influenced by his father and by his *oom* (uncle) Cent, husband of Anna's sister Cornelia. Uncle Cent was warm and engaging, wealthy, and childless. He was a partner in the Goupil & Cie gallery in The Hague, with branches in Brussels, London, and Paris. Goupil bought and sold works by the important artists of the day—Bouguereau and Gérôme, for example. Among their well-heeled customers were Willem III, king of the Netherlands, and Queen Victoria of Great Britain. Goupil bought reproduction rights and made high-quality prints, winning a gold medal at the 1867 World's Fair.

Uncle Cent convinced him to become an office clerk at the gallery in The Hague, and Vincent embraced the family business. He adopted city dress and hobnobbed with the cosmopolitan clien-

The same year young Vincent dropped out of school in Tilburg, shaming the family, Uncle Cent was knighted by Willem III into the Order of the Eikenkroon.

tele. He developed a passion for reading art history books, visited the Vermeers and Rembrandts at the Mauritshuis, and traveled to Amsterdam to see the works of Jan van Eyck and Peter Paul Rubens. Young experimental artists influenced by painters of the Barbizon School in France visited the Goupil gallery, and Vincent heard them discussing their style and practices: wandering the countryside and painting *en plein air*. They would become known as artists of The Hague School. Goupil & Cie was resistant to these painters who were blurring the realism of the Old Masters, and it would be years before they thoroughly embraced the painters of the Barbizon School. Meanwhile, Vincent was submersed in imagery, color, and technique as he sorted and recorded originals and prints of a rich cadre of artists in the Goupil stable. This was the most immersive art education imaginable.

When a young French painter named Claude Monet moved to the Netherlands in 1871, he went virtually unnoticed.

Vincent became adept at selling the paintings, photographs, and prints and left the back room to make sales trips to

Brussels, Antwerp, and Amsterdam. He was proudly surpassing his uncle Cent's expectations, and his life seemed to be changing. What was not changing, however, was his persistent melancholy and loneliness. Despite his unhappiness at the Zundert parsonage, he missed his family and their life. The family moved farther away to Helvoirt, reinforcing Vincent's feelings of abandonment. This seemed a wound that would not heal. When Theo was fifteen, he came to The Hague to visit Vincent. It was this reunion that began the deluge of correspondence between the two that would become our window into van Gogh's world.

Vincent was surrounded by extended family, and through them he met a beautiful young woman, Caroline Haanebeek, and became completely infatuated. When Caroline announced her engagement to Vincent's cousin, he was devastated. For some time after Caroline's marriage, van Gogh fruitlessly sent her seductive and suggestive letters, poems, and erot-

ic prints. Appalled, Caroline turned her back on Vincent. His social life became drinking, playing cards, and taking up with prostitutes. Vincent wrote to Theo that he was empathetic toward these "women who are so damned" and had a "special affection" for them. Vincent lost himself in this back-alley world. His performance at the gallery began to slide and his actions scandalized his family. Vincent was slipping from the heights he had reached, and Uncle Cent was outraged by his behavior.

Theo had taken a position in the back room at the gallery in Brussels to learn the trade. Uncle Cent, however, could not have Vincent, with his seedy reputation, in his gallery. He transferred him to the London branch, a wholesale operation, so Vincent would have little contact with the clients.

In 1873, London was the largest city in the world. It was roiling with sensory chaos—endless traffic, swarms of pedestrians, hawkers, and factories. London boasted thousands of brothels, dance sa-

Vincent began to search for love and intimacy where it would not be found: brothels.

loons, and night houses. Unable to make friends in London, Vincent bought companionship.

In 1885, just before Goupil's was to open a new gallery, Uncle Cent terminated the London experience and sent Vincent to Paris.

Van Gogh's mental state and emotions continued to unravel. At times he would throw himself into his work at the gallery; at others he was offensive and depressed.

Vincent arrived in a Paris art world turned on its head. Young rogue artists calling themselves the Société Anonyme were shaking up the traditions by fearlessly exploring light, color, and texture in their paintings, tossing aside the formality and structure of the previous generation of painters. These artists had embraced a derogatory word flung at their work by a self-righteous and dismissive critic: *impression*. Claude Monet, Pierre-Auguste Renoir, Edouard Manet, and Edgar Degas wore it like a badge and called themselves Impressionists. The public criticism of the work of these artists created a furor swirling around van Gogh, yet he was oblivious.

Vincent's focus was not art—he had

found religion. While still in London, Vincent likely joined the crowds listening to Charles Haddon Spurgeon, a charismatic evangelical Baptist. Redemption was hovering around van Gogh, as were the many self-help books that he devoured. In a time when social enlightenment included the faux sciences of phrenology and physiognomy, van Gogh drew on these theories. With moralistic fervor, he explored the myriad of books channeling Christianity.

It was as if he was floating in a bubble through one of the most important artistic revolutions in history— one that would later have such impact on his own art.

Vincent's position at Goupil's ended in humiliation and failure. He decided he wanted to become a missionary, so he returned to the Netherlands to study for his ministry in earnest. He gave rambling, convoluted sermons with strange references and allegories. Evidence of a mental breakdown began to leak into his letters. His handwriting became scratchy and his letters to Theo were incoherent.

If van Gogh had lived in an earlier time, he may have been revered as an ecstatic, but that was not the case in nineteenth-century Amsterdam.

Vincent's erratic behavior and the epic failures he was collecting mired him. He was ousted from two evangelical schools.

He had a vision that took him to the Borinage to preach informally to the downtrodden people in the darkest of occupations: the coal mines. He enjoyed a short period of stability in his mission until, in 1879, he began spiraling into delusion. He refused to eat or bathe and slept on a straw mat in a hut. He wandered the countryside, a filthy madman living in the wild dialogue in his head.

His father tried to commit him to an insane asylum, but van Gogh made a dash for freedom.

> *"A great fire burns within me, but no one stops to warm themselves at it, and passers-by only see a wisp of smoke."*

The mental and physical trauma triggered another sharp turn for van Gogh. He returned to the Borinage and with the same fervor he had applied to his evangelism, began to draw. He carried a sketchbook and charcoal, recording the miners and the families of the countryside. His sketches were clumsy. He spent hours drawing figures and working on perspec-

tive, writing that the practice "invigorates my pencil."

Theo had begun to support him financially to ease the burden on their parents. In 1880, van Gogh left the Borinage and the darkness of the mines and went to Brussels. It was flourishing and tolerant of the artistic and intellectual misfits of Paris society: Victor Hugo, Charles Baudelaire, Arthur Rimbaud. Vincent continued his self-training and while his drawing improved, his volcanic personality did not. Vincent professed to want companionship but left a trail of damaged relationships. Brussels did not embrace the volatile young man with such extreme passions.

He copied favorite works by Jean-François Millet and Theodore Rousseau repeatedly, training his hand.

Vincent had three drivers, all at odds with each other. He wanted to be the man of his parents' expectations; he desired companionship and to help suffering people; and he was a slave to his demons and the tidal wave of delusion and emotional extremes they inflicted. The convergence of these led him to the determination to marry, thinking this would steady him.

Vincent had admired his cousin Cornelia, known as "Kee," when he was young. She had married Christoffel Vos, a preacher, and had two small children. Kee was to visit, grieving over the recent deaths of her husband and younger child. Vincent's imagination formed a scenario removed from reality. Suffering was a magnet for Vincent's heart and he wanted to marry Kee and help her and the surviving child. Acting on the fantasy dialogue in his head alone, he proposed. Kee reeled from the absurd assumption. Her response was swift and cut like a knife: "Never, no, never." She returned to her home in Amsterdam. For months, Vincent sent impassioned and delusional letters to this woman he barely knew. At one point he even thought he would abduct her. Both Kee's family and Vincent's demanded he cease communication with her. This incident was the final straw for his parents, and Dorus threw him out of the house.

Vincent was now twenty-four years old and had just begun to paint. He traveled

He worked himself into a romantic state by consuming Victorian literature of love: Charlotte Brontë's *Shirley* and *Jane Eyre*.

to The Hague and took painting lessons from his cousin Anton Mauve, a well-respected and successful painter represented by Goupil. This relationship soon ended. Vincent was an emotional pugilist; sooner or later he threw angry punches at everyone who could have helped him.

Van Gogh paid poor peasant women and prostitutes to model for his studies of the human figure. He met a young pregnant woman selling herself to survive. She began to model for van Gogh. Clasina Maria Hoornik, called "Sien," had few alternatives to support herself. Vincent looked to Sien to form his own family of misfits. Sien was tough and angry from years of sleeping in the streets. Her face scarred by smallpox, she looked older than her years. Vincent was twenty-nine and suffering from fevers and weakness. He entered the hospital and was treated for venereal disease, while Sien had another man's baby boy, whom she named Willem, giving him Vincent's middle name. Van Gogh was in a delusional, euphoric state about his happy little family.

Vincent called Sien an "angel." He felt that she was able to calm his demons. He thought her struggles heroic in the face of poverty.

In 1882, van Gogh began painting with wild, obsessive brushstrokes, sometimes mixing his oils directly on the canvas. He painted in a storm to evoke a storm on his canvas. Vincent had become a local eccentric, publicly ridiculed for his wild demeanor and dragging his unwieldy painting materials through the town. His fantasy family became an irritant to him. His drawings failed to attract acceptance. Vincent turned thirty in a dark state.

Goupil's was beginning to accept and promote the Impressionists. Vincent railed against the group, disliking their style. When told that their use of color and light was more saleable, he responded by painting in dark and dusky hues. His life was spiraling once again: Sien was angry and aggressive; he and Theo were at odds; he had no money; and his health was deteriorating. Vincent packed up his materials and left Sien and The Hague.

Vincent had been involved with Margot Begemann, a wealthy neighbor, who took strychnine because of their scandal and

nearly died. His daily fights with his father were loud and aggressive, and van Gogh even threatened Dorus with a knife. His father wrote to Theo that the fights were going to kill him. Theodorus van Gogh died suddenly of a stroke in March 1885. Years of a volatile relationship with Vincent and the shame brought on his family by his son's actions may have contributed to the death.

Vincent visited the new Rijksmuseum in Amsterdam, and studying the paintings turned an internal page in the artist. At the museum he was taken by Rembrandt's *The Jewish Bride*. Quite suddenly, van Gogh's impassioned defense of black pivoted to celebrating rich colors in his paintings. He spent the fall outdoors rendering the landscape in quick jabs of color on his canvas. True to form, van Gogh's inner darkness was not eased by the natural beauty he captured on canvas. Self-abuse in the form of starving in his filthy studio, derision by his remaining family and the villagers, increasing

Conversely, when his mother broke her hip, the warm, caring heart of van Gogh led him to nurse her back to health with a singular focus, Dorus noting this kindness as well.

debt, and another scandal with a prostitute drove Vincent to Antwerp. After months of drinking, illness, and suffering the physical abuse of mercury treatments for syphilis, van Gogh created his first self-portrait: *The Head of a Skeleton with a Burning Cigarette.*

> "I put my heart and soul into my work, and I have lost my mind in the process."

In 1886, van Gogh showed up unexpectedly at Theo's apartment in Paris. Theo arranged for Vincent to join the atelier of Fernand Cormon, where he met Henri de Toulouse-Lautrec and Émile Bernard. Unable to afford models, van Gogh used himself. His painting career lasted ten years, and within that time Vincent painted thirty-seven self-portraits. His paintings showed experimentation with density of paint, brushstroke technique, and use of light. His resistance to the Impressionist palette was fading. Vin-

He went to the barber, had wooden teeth made to fill his toothless mouth, and bought new clothes.

cent began to paint sunflowers in swirling acidic colors.

Theo's career was moving forward with the times. Goupil tapped him to take the lead in acquiring emerging artists and exhibiting their work. He had Goupil mount successful exhibitions of the work of Claude Monet, Edgar Degas, Camille Pissarro, Toulouse-Lautrec, Georges Seurat, and Paul Gauguin. The brothers seemed finally to have reached a plateau of affection and respect. It appeared that Vincent was stabilizing emotionally, when he left Paris suddenly in 1888 and went to Arles. Theo was in chronically poor health now, the result of syphilis. It could be that Vincent left because he wanted to spare his brother the pain of his own chronic mental breakdowns.

Spring in Arles was bursting with color and imagery. Vincent painted in vibrant hues. A starry sky was a memory from childhood. Walking near the water at Arles, he saw the dark purple-black of the night sky touch the horizon of shimmer-

Vincent developed an interest in *japonisme* and began collecting inexpensive Japanese woodcuts called *crépons,* which influenced his art.

Vincent filled his canvases with cherry and almond blossoms.

ing dark water and the flickering stars in jewel tones. He captured this scene of bursting stars softened by their auras and the reflected streetlights on the horizon dripping into the water.

He moved to the run-down "Yellow House," believing he saw the potential for an artists' community in the building. Van Gogh famously painted his bedroom on canvas with its yellow chairs and exaggerated perspective. This was his refuge from hostile neighbors, who found him unruly and deranged.

> *"I dream my painting and I paint my dream."*

Intensely lonely, Vincent invited Paul Gauguin to stay with him. Gauguin was reluctant. Vincent was obsessed with the idea of an artists' utopia. Gauguin, who had walked away from a banking career to paint and had six children to support, demanded money from Theo to stay with his brother. Gauguin stalled, generating

Writing to Theo, "My mind pretty well cracked."

anxiety in Vincent. At this time, Vincent's sister Wil wrote to tell him that Uncle Cent had died. Unforgiving in death, his will left nothing to Vincent yet ensured the rest of his siblings were well taken care of. Theo's windfall enabled him to offer Gauguin a stipend plus travel money to Arles.

Paul Gauguin arrived in Arles carrying his bigger-than-life personality. Soon after, Theo sold five of his paintings and several ceramic pieces and sent a check of over 1,500 francs. It was a blow for Vincent. Every detail of the way they painted and lived their lives was at odds. They fought continuously. Vincent's mind grew darker; he was suspicious and paranoid. When Theo wrote that he was engaged to marry Johanna Bonger, Vincent felt he was losing his brother. At this low point, delusional and drunk, Vincent stood at his mirror, grabbed a straight razor, and sliced off his ear. Jolted to reality by the bloody mess, van Gogh bandaged his head in a towel, wrapped his ear in a piece of

Paul threatened to leave but did not in order to maintain his lucrative relationship with Theo.

newspaper, and delivered it to a prostitute for Gauguin at a local brothel with the scrawled message, "Remember me." Vincent would spend the next five months in and out of hospitals and padded cells, incoherent and hallucinating. The police dragged him from the Yellow House twice, the second time as a result of a petition signed by more than thirty neighbors who feared him.

Faced with losing his brother to marriage, on May 8, 1889, Vincent voluntarily committed himself to the asylum of Saint-Paul-de-Mausole in Saint-Rémy. Vincent was diagnosed with "latent epilepsy" (seizures of the mind), causing explosions in the brain like neuro-fireworks. Therapies included doses of bromide, a sedative, and a two-hour therapeutic bath twice a week. Van Gogh seemed calm and peaceful with all the pressures of money and competition erased from his life. Here he could sketch and paint without ridicule. He made 130 paintings at Saint-Rémy, including the exquisite, *japonisme-*

influenced *Irises,* painted in the asylum's gardens. Each iris is painted curving naturally. Vincent imagined a starry night engulfing the valley. He was not allowed out at night and could paint only in the day. He must have imprinted swirling stars seen through his barred window and the fireworks in his brain, then transferred their brilliance to canvas during the day.

> *"I often think that the night is more alive and more richly colored than the day."*

Dr. Peyron, the director, allowed him to go to Arles with an attendant to pick up his belongings. Van Gogh suffered a massive attack, blacking out and becoming incoherent. He tried to eat dirt and his paints and was confined to his room for a month. Slowly, van Gogh regained his mind and his health and strode out with his easel to paint. This pattern was to repeat continuously: recuperate; seizure; recuperate.

While these mental cyclones were

Vincent appeared content at the asylum, hiding the disturbance in his brain.

racking van Gogh, the recognition in the art world that had escaped him was beginning to happen. Perhaps Vincent was simply getting out of his own way at last. Theo was impressed with the vibrancy of color in the paintings Vincent sent from Saint-Rémy. He exhibited *Starry Night over the Rhône, Irises,* and other paintings at the Salon des Indépendants in Paris alongside works by Toulouse-Lautrec, Seurat, and Signac. This was followed by several showings in Brussels with Les XX. Poet and art critic Julien Leclercq wrote, "His is an impassioned temperament, through which nature appears as it does in dreams, or rather, in nightmares." Toulouse-Lautrec challenged a dismissive viewer to a duel in defense of Vincent's painting. Vincent made his first and only sale of a painting, *The Red Vineyard,* to Anna Boch for 400 francs.

Theo and Jo's son was born in 1890 and christened Vincent Willem van Gogh after his godfather, who, still in the asy-

Claude Monet declared van Gogh's paintings "the best of all in the exhibition."

lum, dedicated his delicate and exquisite painting *Blossoming Almond Tree* to his newborn nephew.

Vincent continued to cycle through dark episodes in the asylum, requiring restraints and confinement. Pissarro introduced Theo to Dr. Paul Gachet, who practiced in Auvers-sur-Oise. Gachet was an amateur painter and had treated the physical and mental ills of many of the Impressionists. Theo moved his brother to Auvers under the care of Gachet.

Vincent settled in the picturesque village and produced eighty paintings with no seizures. Gachet became convinced that Vincent was cured. Theo and family came to visit him in Auvers.

The apparent mental stability may have been a charade, however. Unsent letters describe Gachet with harsh words. Dark thoughts were churning in van Gogh's mind. Theo's mental and physical health was rapidly declining; he was making uncharacteristically risky decisions. In a final visit by Vincent to Paris, the house-

This may have been the happiest time together that Vincent and Theo ever had.

hold erupted into fighting and violence until Vincent retreated to the seclusion of Auvers.

On July 27, 1890, Vincent returned from a day painting in the countryside in great pain. Mme. Ravoux, the café proprietress, called Dr. Gachet, and Vincent admitted that he shot himself in the chest. Gachet could not remove the bullet. Theo rushed to Auvers and found his brother sitting up, smoking his pipe. The brothers spoke at length as Vincent grew weaker. He died on July 29.

His last letter to Theo, requesting painting supplies, was still in his pocket.

The Catholic church in Auvers refused to have a funeral because his death was said to be a suicide. Vincent's casket, covered with his beloved dahlias and sunflowers, was buried in the cemetery at Auvers-sur-Oise.

There is controversy about van Gogh's death. It is possible that he was shot by someone else. Van Gogh's delusions made him an unreliable witness, even to his own death.

Vincent's tragic story doesn't end here.

This manic, irascible man with a soft heart for those suffering, had found the peace that was impossible in life. At his burial, Dr. Gachet said, "There were only two things for him: humanity and art. Art mattered to him more than anything else, and he will live on in it."

Theo had spent his entire life on the rugged path of supporting and loving his brother. Vincent's death broke Theo. Syphilis had spread to his lungs and brain, causing some paralysis. He became unhinged and, in a burst of anger and delusion, quit his job at Goupil & Cie. He had a complete breakdown in October 1890 and was admitted to an asylum in Passy. He soon was unable to walk. Jo resisted the doctors' diagnosis and treatment. She had never been told of his syphilis and rejected that fact. She moved Theo to an asylum in Utrecht, in the Netherlands. Theo became incoherent and violent. He died in January. The tragedy of the van Goghs continued, with younger brother Cor committing suicide

in 1900 and Vincent's sister Wil committed to an insane asylum for the remainder of her life. In 1914, Jo had Theo's body moved to Auvers-sur-Oise and buried next to Vincent's. Brothers together: *Ici Repose.*

nt Vincent Vincent
Vincent Vincent Vin
nt Vincent Vincent
Vincent Vincent Vin
nt Vincent Vincent
Vincent Vincent Vin
nt Vincent Vincent
Vincent Vincent Vin
nt Vincent Vincent
Vincent Vincent Vin
nt Vincent Vincent
Vincent Vincent Vin

Vincent Vincent Vin
ent Vincent Vincent
Vincent Vincent Vin
ent Vincent Vincent
Vincent Vincent Vi
ent Vincent Vincent
Vincent Vincent Vin
ent Vincent Vincent
Vincent Vincent Vin
ent Vincent Vincent
Vincent Vincent Vi
ent Vincent Vincent